SCULPTURE ON MERSEYSIDE

TATE GALLERY LIVERPOOL

NATIONAL MUSEUMS & GALLERIES
ON MERSEYSIDE

1988

Merseyside has unusually rich collections of sculpture in its galleries, and on its streets. The city of Liverpool plays host to some of the finest nineteenth and early twentieth century statues in Britain. The range, variety and quality of these monuments means that Liverpool (with Glasgow) might even be seen to outshine London.

A number of sculptors and collectors with special links with Merseyside have contributed to the wealth of sculpture in the galleries. The area has inherited the work of sculptors from Liverpool (Benjamin Spence, John Gibson, John Deare, C.J. Allen, or more recently, Tony Cragg) or sculptors who had particularly close working relationships with the area (Richard Westmacott, Francis Chantrey, F. W. Pomeroy, W. Goscombe John). Famous Merseyside collectors have done even more to endow the city with the sculptural riches of their collections: Roscoe, Blundell and Lever in particular. The Liverpool Museum has also benefited from its local patrons, though their gifts may have more exotic origins.

The collections in the National Museums & Galleries on Merseyside are particularly rich in eighteenth and nineteenth century British sculpture. The Lady Lever and Sudley Art Galleries house exceptional collections of turn of the century pieces by the sculptors known as *The New Sculptors*. The Walker Art Gallery is opening a new sculpture gallery to display the work of the neo-c' closely connected with Li

visitor up to the end of the nineteenth century, and it, with the Lady Lever and Sudley, form the perfect foil to the Tate Gallery Liverpool's current long-term (three year) sculpture display of twentieth century British sculpture. The Liverpool Museum may appear to be the black sheep in this selection, but we have wanted to assert that sculpture is by no means a Western prerogative, and that it can be done in materials very different to those used by Western sculptors in previous centuries. In this respect, the rich variety of sculpture in the Museum is an important reference point from which to view the developments in modern sculpture in the Tate. It is on this basis that collaboration between the National Museums & Galleries on Merseyside and Tate Gallery Liverpool has been initiated; our sculpture displays provide an obvious platform from which to begin to foster a working relationship which we hope will be fruitful in many other ways. It is a small, but symbolic initative, just as this selection of sculpture is merely a 'taste' of what can be seen on Merseyside. It aims to orientate the newcomer to the area, and to introduce the significant sculptural 'sites' on the map. It is hoped that the creation of Chavasse Park opposite the Albert Dock by the Department of Recreation and Open Spaces of Liverpool City Council and the Merseyside Development Corporation will provide a site for the sculpture of the future. Tate Gallery Liverpool and British Rail are at present collaborating with Claes Oldenburg, Coosje van Bruggen, Ian Hamilton Finlay and Sue Finlay on sculpture projects for the city.

Although the selection cannot hope to represent all the sculptors who have worked on Merseyside, it tries to give a broad range of the types of sculpture (statue or equestrian monument, war memorial, tombstone, bust, relief panel, idealised work); of private and public work; of work done as commission and, more common recently, work done for the artist's personal satisfaction. The selection (with the exception of Epstein's figure on Lewis's) does not include sculpture on buildings – another area in which Liverpool is notably rich. It does however illustrate a very wide range of materials and of techniques; as a 'taste' it hopes to be suggestive of the diversity of potential in sculpture.

The willing cooperation of various curators on Merseyside has been indispensable. I should like to thank Alex Kidson of the Walker Art Gallery; Liz Kwasnik, Piotr Bienkowski and Yvonne Schumann of Liverpool Museum; Lucy Wood of the Lady Lever Art Gallery; Colin Simpson of the Williamson Art Gallery; and Janice Carpenter at the University of Liverpool Art Gallery. The project was initiated by Edward Morris and Lewis Biggs of the Walker and the Tate respectively. A substantial number of the colour photographs were specially commissioned from Alex Saunderson; the rest came from the respective museums. The transparency of *Jacob and the Angel* is courtesy of the Granada Foundation.

Penelope Curtis, Assistant Curator, Tate Gallery Liverpool

A WALKER ART GALLERY
 William Brown Street, Liverpool L3 8EL
 Open: Monday–Saturday 10am–5pm,
 Sunday 2pm–5pm

B LIVERPOOL MUSEUM
 William Brown Street, Liverpool L3 8EL
 Open: Monday–Saturday 10am–5pm,
 Sunday 2pm–5pm

C TATE GALLERY LIVERPOOL
 Albert Dock, Liverpool L3 4BB
 Open: Tuesday–Sunday 11am–7pm, closed Monday

D WILLIAMSON ART GALLERY & MUSEUM
 Slatey Road, Birkenhead L43 4UE
 Open: Monday–Saturday 10am–5pm
 (Thursday 10am–9pm) Sunday 2pm–5pm

E LADY LEVER ART GALLERY
 Port Sunlight Village, Bebington, Wirral
 Open: Monday–Saturday 10am–5pm,
 Sunday 2pm–5pm

F THE ORATORY
 St James Road (by the Anglican Cathedral), Liverpool 1
 Open: Saturday 2pm–4.30pm 3 Sept–29 Oct 1988,
 and 1 April–28 Oct 1989

G SUDLEY ART GALLERY
 Mossley Hill Road, Liverpool L18 8BX
 Open: Monday–Saturday 10am–5pm,
 Sunday 2pm–5pm

H FESTIVAL GARDENS
 Dingle Lane, Liverpool 17
 Open summer months: call Tourist Information on
 051-709 3631 for further details

I UNIVERSITY OF LIVERPOOL ART GALLERY
 3 Abercromby Square, Liverpool 7
 Open: Monday–Friday 12–2pm (Wednesday,
 Friday 12–4pm)

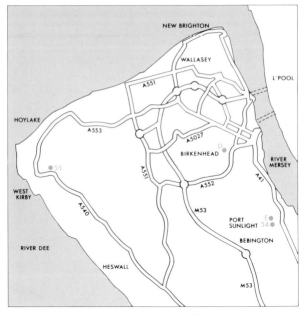

The letters on the maps refer to the galleries and museums listed on the previous page. Sculptures not in a gallery or museum are indicated on the maps by the page numbers on which they appear in the catalogue.

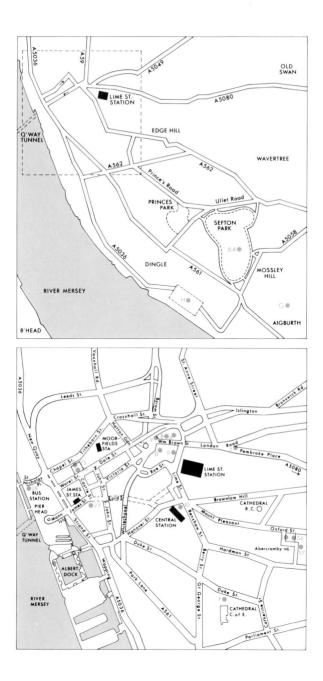

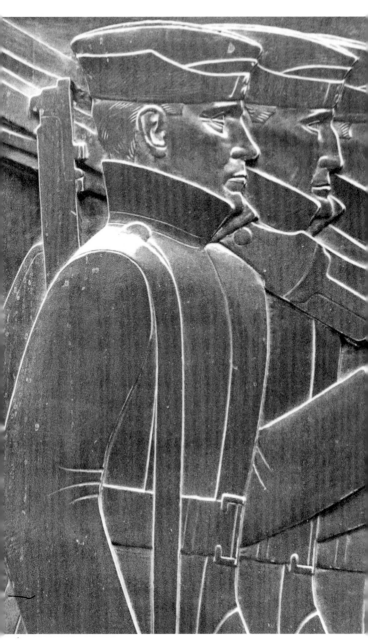

The Cenotaph 1926–30 by Lionel Budden (1887–1956) and
Herbert Tyson Smith (1883–1972)
In 1926 a competition was announced for this monument,
and 767 drawings and 39 models were submitted. Budden,
a Liverpool architect, was declared the winner, but the
Cenotaph was not completed for another four years owing
to the perfectionism of his sculptor, Tyson Smith, another
Liverpudlian. When it was unveiled, in the place where the
statue of 'Disraeli' had previously stood, a crowd of 80,000
was in attendance. Budden and Tyson Smith had already
worked together on the Birkenhead war memorial.

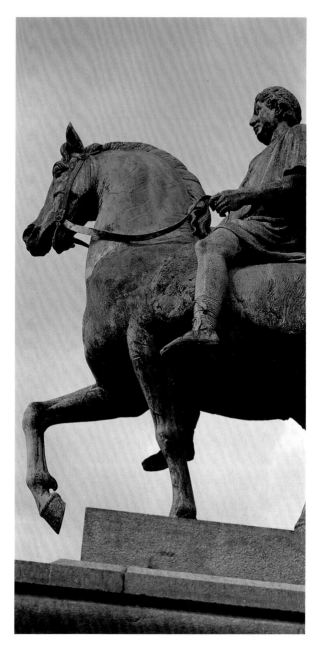

George III 1822 by Richard Westmacott (1775–1856)
A committee was set up to erect this monument in 1809, but was still debating their sculptor nearly a decade later. In 1815 they were considering Westmacott, Bacon and Wyatt, but as late as 1821 Gibson was hoping that he might be able to execute it. In 1818 a contract had already been signed with Westmacott who was charged to deliver the statue within three years. Westmacott began by considering using a prancing horse, but decided to use the classic Roman model derived from the statue to Marcus Aurelius in Rome.

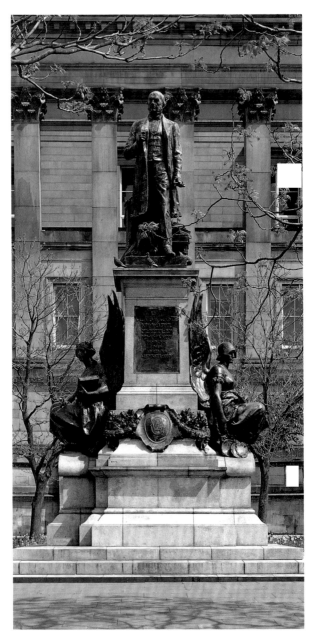

Gladstone Monument 1904 by Thomas Brock (1847–1922)
Gladstone was born in Liverpool, and this monument was
erected by his townsmen with a public subscription. Brock
both designed and executed the monument. On the three
sides of the pedestal are figures representing Justice, Truth
and Brotherhood, and on the pedestal, Gladstone is shown
in the act of delivering a speech.

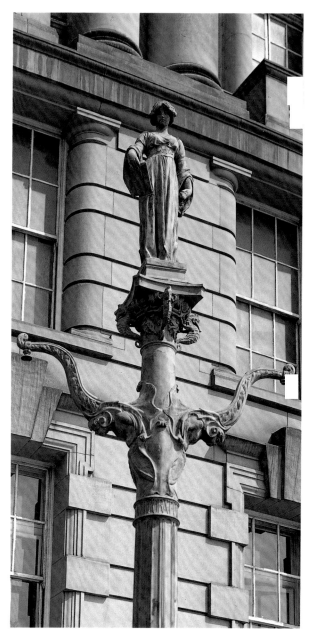

Lamp Standards 1902 by F.W. Pomeroy (1856–1924)
Pomeroy worked on this building with his long-standing
architectural colleague, E.W. Mountford. The lampstands
are full of delightful detail: exotic fish heads, children's
heads, seahorses and conch shells which are typical of turn
of the century interest in decoration derived from natural
forms. This female figure is paired with a male figure of a
navigator holding sextant and protractor.

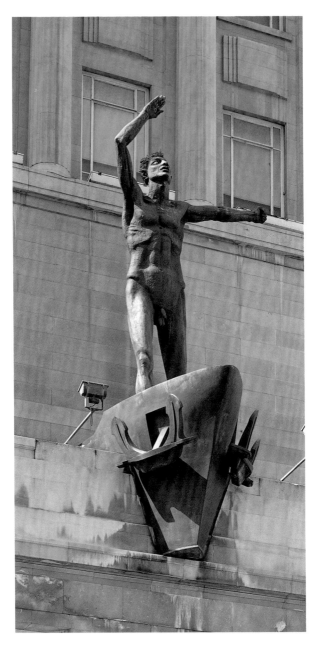

The Spirit of Liverpool Resurgent 1954–56 by Jacob Epstein
(1880–1959)

The former Lewis's building was ruined in the Blitz, and this
figure was meant to symbolize 'the struggle and
determination of the city of Liverpool to rehabilitate itself
after the destruction of the war'. Lord Woolton unveiled the
statue in 1956. The *Liverpool Echo* reported the 'few gasps at
the uncompromising masculinity of the 18ft high figure of a
youth, poised nude on the prow of a ship', and the papers
received many critical letters. Under the figure there are
three six foot panels in concrete by Epstein.

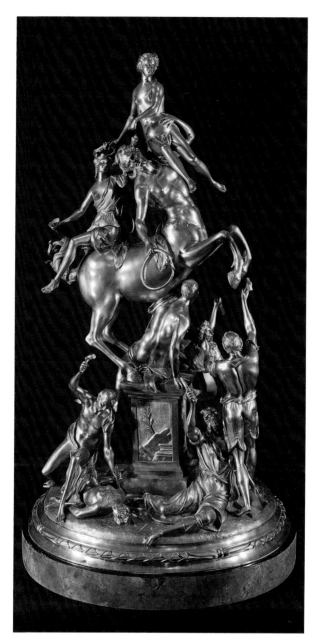

Homage to Sculpture by Francesco Bertos (active 1683–1733)
This is the only gilt bronze by Bertos that is known to us. It
shows the beautiful Deianira being carried off by the centaur
Nessus, but its real subject is the sculptors at work, for
Deianira is simply a typical mythical theme of the kind on
which sculptors were commonly engaged.

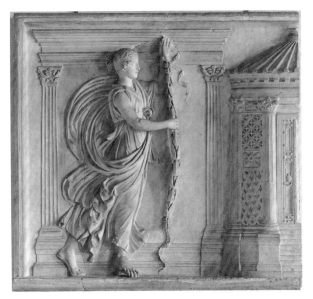

Girl before a Round Temple by Cavaceppi (1716–1799)
This relief is now thought to be by Cavaceppi, although it
has been interpreted as an antique work, and may well be a
deliberate forgery. It had belonged to Pope Sixtus V, and
when it was sold in England in 1800, it was described as the
'finest specimen of ancient sculpture that has reached our
times'. The Merseyside collector Henry Blundell affirmed
that the 'elegant figure of the nymph etc. have always
rendered this bass–relief very valuable in the eyes of the
connoisseurs'.

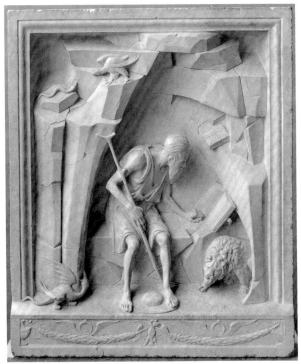

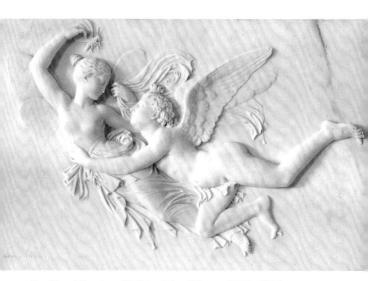

Cupid and Psyche c.1854 by John Gibson (1790–1866)
Gibson carved several versions of this legend in his career.
Gibson's family had moved to Liverpool when he was nine,
and he soon attracted the attention of his early patron,
William Roscoe (of whom he carved a bust now in the
University Gallery). His first important piece was a
monument to Blundell in Sefton Church. He was helped by
Thorvaldsen (see page 19) in 1817 when he arrived in Rome,
where he was to spend most of the rest of his life. As befits
Liverpool's place in Gibson's life, there is a large holding of
his work here.

St.Jerome reading in a Cave 1470–72 *(opposite, below)* by
Andrea Alessi (c.1425–1503/5)
Alessi made many stone reliefs of St.Jerome, and most are
still in Dalmatia, where St.Jerome came from. The relief
represents the battle for the faith: the lion, St.Jerome's usual
companion, frightens off the dragon of paganism, while
Christ's eagle fights with Satan's serpent.

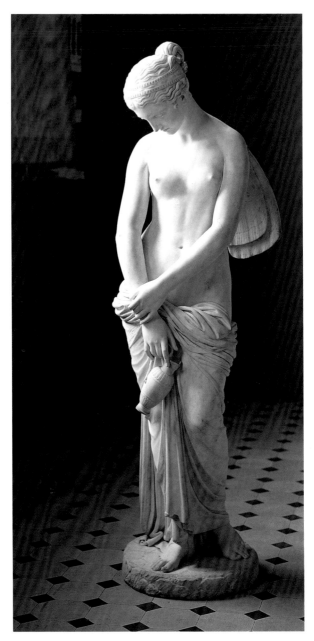

Psyche c.1864 by Benjamin Edward Spence (1822–1866)
Unlike his father, the Liverpool sculptor William Spence,
Benjamin Spence (on Gibson's advice) spent most of his
career in Rome where he trained under R.J.Wyatt. Despite
being based in Italy, a good proportion of his work has
come to rest in his native town. Sculptures by Spence were
positioned in the Sefton and Stanley Park Palm Houses, and
his 'Highland Mary' (a replica of the one at Osborne, Queen
Victoria's Isle of Wight home) is also in the Walker's
collection.

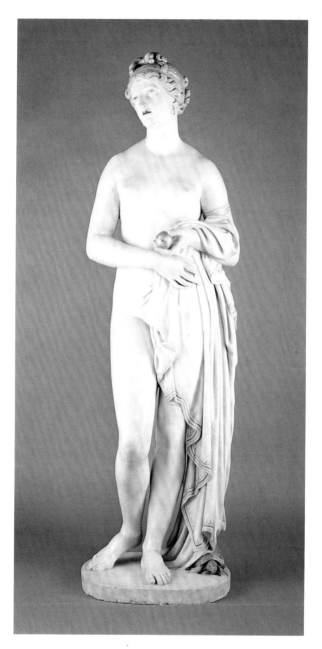

Tinted Venus c.1851–6 by John Gibson (1790–1866)
Gibson was interested in the ancient Greek practice of
colouring marble statues, and the 'Tinted Venus' is the most
famous example of this interest. This statue is the second
version of another Gibson had carved in 1850, and was
commissioned by the Prestons of Liverpool. He worked on
it regularly and lovingly over five years, and considered it
superior to the first statue. Refining it to achieve soft and
undulating lines, he then tinted it, and was reluctant to hand
it over to the Prestons. When it was exhibited at the Great
Exhibition of 1862 it aroused a lot of controversial interest.

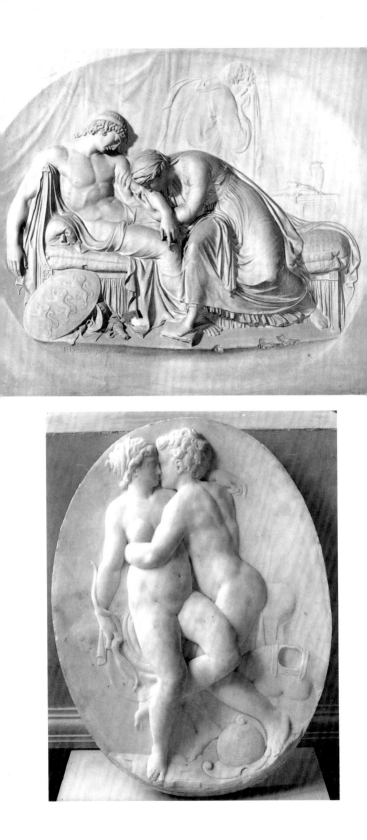

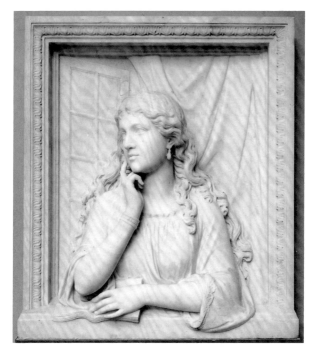

Juliet at the Window by G.G.Fontana (1821–1893)
Fontana exhibited this piece, taken from Act II, Scene 2 of
Shakespeare's *Romeo and Juliet* at the 1874 Royal Academy
exhibition. It was bought by the Liverpool shipping
magnate George Holt the same year, and immediately
presented by him to the Walker.

Queen Eleanor sucking Poison from her Husband's Wound
c.1786–8 (*opposite, above*) by John Deare (1759–1798)
Deare was born in Liverpool, the son of a jeweller.
Although he studied at the Royal Academy, he returned to
work in Liverpool. In 1785 the Royal Academy sent him to
Rome for three years, where he was besieged with work.
He made 'Queen Eleanor' for Sir George Corbett and this
cast was sent to the Royal Liverpool Institution. He also
received commissions from Henry Blundell. He settled
down in Rome, but died at the age of 39.

Mars and Venus (opposite, below) by Stoldo di Gino Lorenzi
(1533/4–1583)
It is not completely certain who carved this marble relief,
which shows the God of War and the Goddess of Love
together. Although it is now thought to date from the
Florence of the 1550s, it had been dated to the 18th century.
However the style and the subject – the open eroticism of
the poses and the un-archaeological approach to the
armour – both suggest the 16th century. It was acquired by
Blundell in the early 1800s, and is engraved in the album of
the *Principal Statues at Ince*.

The Mower 1884 by W. Hamo Thornycroft (1850–1925)
'The Mower' is an important work for English sculpture
because it signals a move away from ideal, classical and
pretty subjects. Nevertheless, its subject was more than
simply the contemporary worker, for it was first exhibited
with a passage of poetry as its caption (Arnold's *Thyrsis*,
a lament for a dead friend), and is essentially a mood study;
an attempt to catch a figure deep in thought, and to transmit
this 'interior world' to the viewer.

Walker Art Gallery

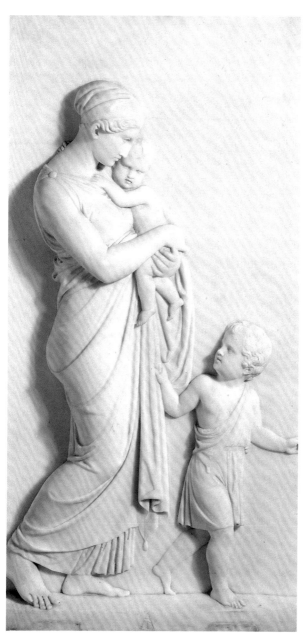

Christian Charity 1810–34 by Bertel Thorwaldsen
(1770–1844)

Like Flaxman, Thorwaldsen (who was Danish) had a huge
influence on European sculpture through his interest in and
dissemination of the language of classical art. At the period
when they were in Rome, archaeological digs were
revealing new knowledge about the ancient world. Their
establishment of a new set of rules from old models – neo-
classicism – set a pattern that was used for a long time after.
From Rome Thorwaldsen and his forty assistants produced
national and royal monuments for noble patrons all over
Europe.

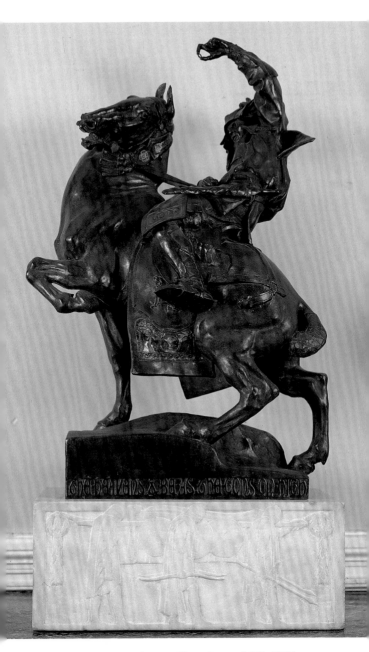

Sigurd 1910 by Gilbert William Bayes (1872–1953)
Sigurd is a character from Old Norse Saga, and, more
particularly, from William Morris's epic *Sigurd the Volsung*
of 1876. Such myths were a source of inspiration to artists
(such as Wagner) in this period. Another characteristic of the
period is Bayes' use of applied decoration. A close look at
'Sigurd' reveals the highlights of blue enamel, an example of
a common interest in colour and mixed materials. Bayes
liked to use fairy-tale subjects, but also produced many
female nudes with no such associations. His most often seen
work must be Selfridge's Clock in London's Oxford Street.

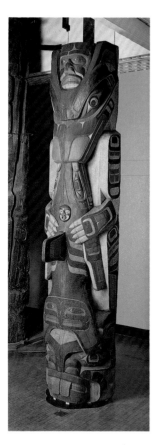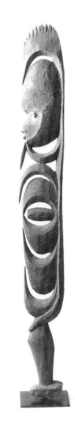

Totem Pole (*above, left*) carved by Richard Hunt (b.1951)
during the International Garden Festival, Liverpool, 1984
Standing some three metres high, this North American
Indian Totem Pole is carved in the Kwakiutl style. Richard
Hunt, the carver, is himself Kwakiutl and is continuing his
family's long tradition of indigenous craftsmanship. The
pole is carved in cedar and was given to Liverpool Museum
by the Canadian High Commissioner to Great Britain.

Yipwon or *Kamanggab* figure (*above, right*), Karawari River
region, New Guinea.
This 'hook' figure portrays many symbolic elements which
are, as yet, not fully explained. It consists of a head with
arms grasping the chin, a series of 'hooks' with a central
projection ending in a single foot. It would have been set in
the porch of a men's house and anointed with a variety of
substances to ensure a successful hunt.

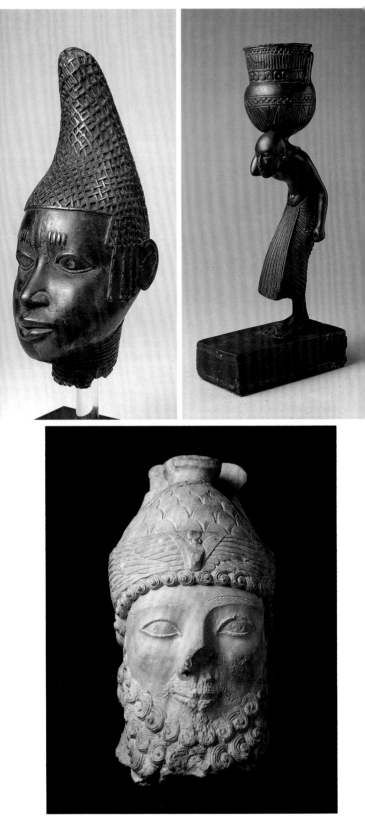

22 *Liverpool Museum*

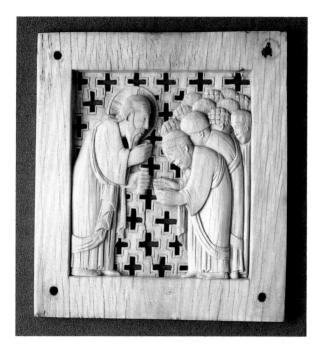

Ottonian Panel, 10th century A.D.
This rare medieval ivory panel, one of eighteen from an altar frontal at Magdeburg Cathedral dedicated by Emperor Otto I (962–973), depicts Christ sending the apostles out to preach. It was part of the collection of Joseph Mayer of Liverpool, and formerly owned by the Hungarian collector, Baron Féjerváry.

Queen Mother Head (opposite, above left), Benin, Nigeria
This early head of a Bini Queen Mother (iyoba) was presented to Liverpool Museum in 1899 by Arnold Ridyard, the founder of Liverpool Museum's noted African collection. Dating from the late fifteenth to early sixteenth centuries it expresses the Bini mastery of the lost-wax (*cire perdue*) method of casting.

Cosmetic Container, late eighteenth dynasty, c.1350 B.C. (*opposite, above right*)
The ancient Egyptian craftsman has captured the natural pose of a Nubian servant carrying a heavy load in this ebony cosmetic container. It was presented to Liverpool Museum in 1867 by Joseph Mayer (1803–1873), a Liverpool goldsmith, whose Egyptian collection was once described as the most important in England outside the British Museum.

Head, Kouklia, Cyprus, c.525 B.C. (*opposite, below*)
This limestone head is thought to depict the king of Palaepaphos in Cyprus, who was also the High Priest of the goddess Aphrodite. It is one of the finest Cypriot sculptures in existence, and was excavated in 1951 by J.H.Iliffe, then Director of Liverpool Museum.

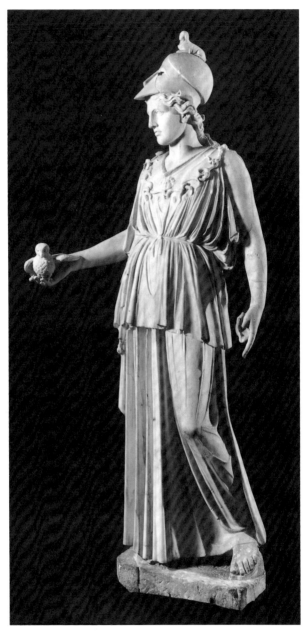

Athena, Roman, 1st century A.D.
The marble statue of Athena was inspired by the Parthenon
Athena of the 5th century B.C., and is the best surviving
piece of its type. It belongs to the collection of classical
marbles formed by Henry Blundell between 1777 and 1809,
originally housed at Ince Blundell Hall, Lancashire.

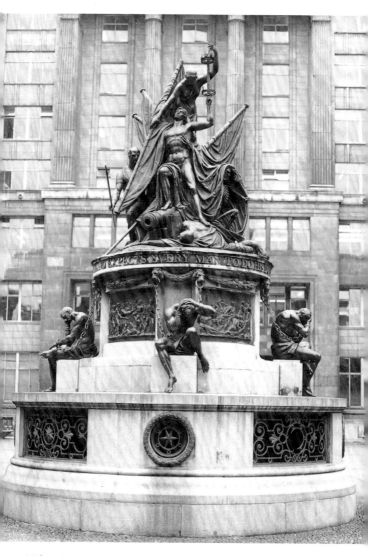

Nelson Monument 1808–13 by Mathew Cotes Wyatt and Richard Westmacott

After the battle of Trafalgar, Nelson's body was brought back to England and buried amid great pomp and circumstance. Plans were immediately launched in various towns to erect monuments in his memory. Liverpool was quick off the mark; although the National Monument in St. Paul's was not erected until 1816, Liverpool had its design prepared by 1808, and the monument was erected in 1813 in the quadrangle of the town hall (from where it was moved to its present position in 1866). Public subscription in Liverpool was notably generous; £9,000 was raised, and put at the disposal of Wyatt whose father was at the time employed as adviser to the architect of the Town Hall. Wyatt entrusted the bronze work to Westmacott, who had previously competed for the entire commission.

Exchange Flags, Liverpool 25

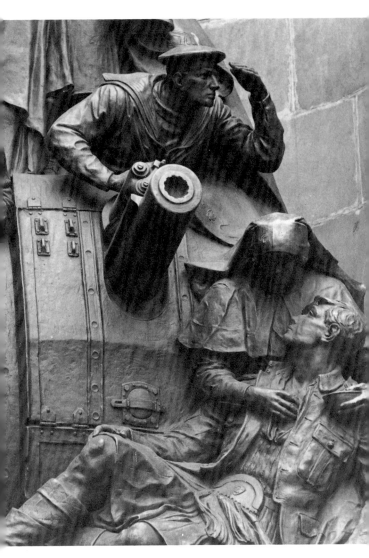

The Newsroom Memorial 1924 by Joseph Phillips
This memorial commemorates members of the Liverpool
Exchange Newsroom who lost their lives in World War
One. It was originally unveiled in the new Newsroom of
Derby House by Lord Derby, and only erected in its present
position in 1953. It had been stored in a safe place during the
rebuilding of the Exchange Building. In its new setting the
memorial is flanked by two sculptures by Siegfried
Charoux. Phillips had also worked on the sculpture at the
Anglican Cathedral, which was consecrated the day after
this memorial was unveiled.

Monument to Queen Victoria 1902–6 by C. J. Allen (1863–1956)
This monument was unveiled by Princess Louise in 1906,
and, unlike most of the buildings around her, 'Queen
Victoria' survived the Blitz. Allen was responsible for the
sculpture on the monument, which was designed by Prof.
Simpson (who had invited Allen to Liverpool to teach
sculpture) and two other architects. Agriculture, Industry,
Education and Commerce are represented on the
monument's base, and five other virtues are represented
above. Most of the modelling of the figures was done in
Allen's Rodney Street studio, and he used some of his
advanced students at the University to help him.

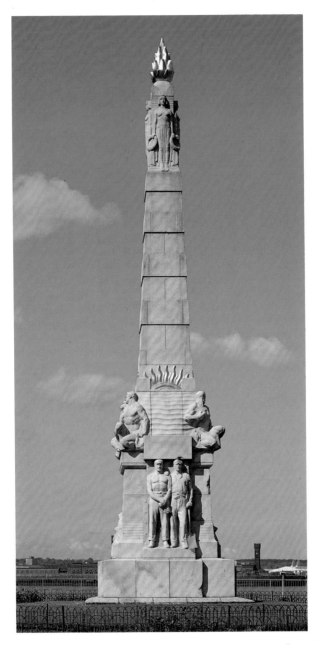

Memorial to the Engine Room Heroes 1916 by W. Goscombe
John (1860–1952)
In 1912 the Titanic sunk, and the monument was originally
only intended to commemorate the 122 engineers lost in this
tragedy, but the international subscribers eventually decided
to dedicate it to all the heroes of the Engine Room lost at sea.
The figures carved into the granite on the corners are Water,
Earth, Sea and Fire. The use of granite in the entirety is
unusual for this early period, and also unusual in Goscombe
John's work.

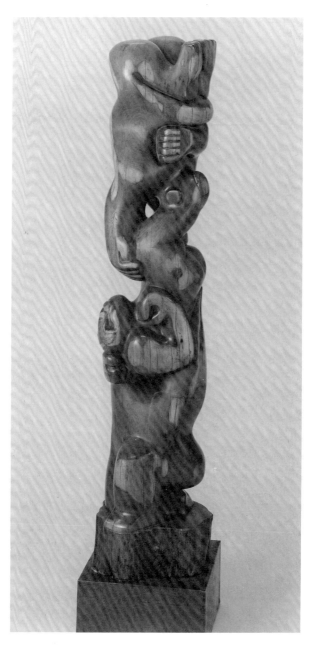

Totem to the Artist 1925–30 by Leon Underwood (1890–1975)
Underwood carved 'Totem' from a trunk of English Yew
that had been growing on Chiswick Mall in London, and
had been condemned by the council. He was concerned to
put the subject matter back into art in this period when
'significant form' was all the rage. He explained, 'The figure
at the top is the artist, his head identical with the heel of his
creation – the middle figure by which he is elevated. His
work is received by the public, the bottom figure'.

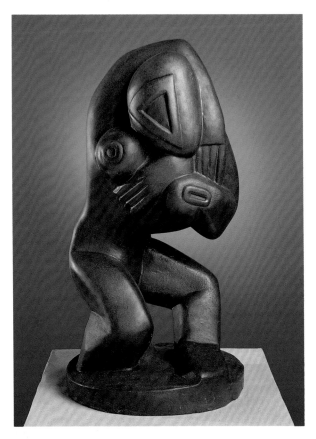

Red Stone Dancer 1913 by Henri Gaudier-Brzeska (1891–1915)

This sculpture is an example of the exceptional carving done by a small group of artists before the First World War, abandoning traditional subject matter and conventions of beauty, and looking instead at non-Western art for inspiration. Epstein had probably inspired Gaudier to try carving directly into the block, allowing the stone's shape to suggest the shape of the sculpture. Before this Gaudier had been modelling in clay, and his stone carving carries a much more concentrated image.

The East Wind 1929 (*opposite*) by Eric Gill (1882–1940)

After Gill carved the three Winds for the London Underground Headquarters in Broadway he immediately made smaller versions for exhibition, of which this is one. On the London Underground building there were eight winds, and Henry Moore carved one of them. The initial idea sprang from the ancient Greek 'Tower of the Winds' in Athens. As these carvings were above the eighth floor, this small relief is a good chance for us to see Gill's expert carving technique at much closer quarters.

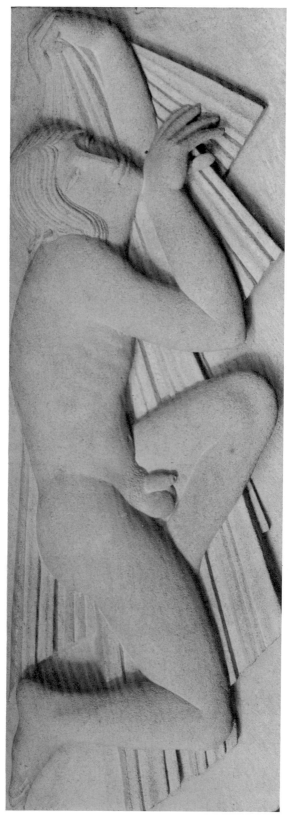

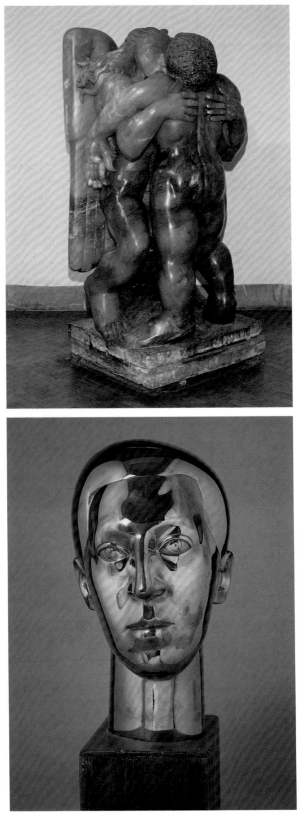

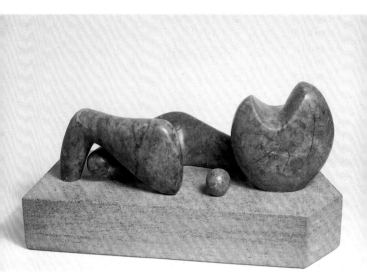

Four-Piece Composition: Reclining Figure 1934 by Henry
Moore (1898–1986)
'Four-Piece Composition' is carved from alabaster sent to
Moore by a Cumberland farmer from his fields. It illustrates
both the rational and the irrational forces that Moore
considered part of art. It dates from the period of Moore's
association with the British Surrealists, and its irrational or
surrealist overtones are evidence of Moore's wish that his
work, though carefully controlled, should also include
'gaps that you can't explain, there must always be a jump'.

Jacob and the Angel 1940–41 (*opposite, above*) by Jacob Epstein
(1880–1959)
Epstein was a pioneer in direct carving (attacking the stone
directly without any prior model to work from) early in the
century, and he continued to carve, though less regularly,
throughout his career, working increasingly on very large
pieces such as this. The subject of Jacob wrestling with the
Angel is a classic one for artists, for whom it symbolizes
their own struggle with their material. It is particularly
apposite in this case, in view of the sheer weight of the
alabaster block.

Osbert Sitwell 1923 (*opposite, below*) by Frank Dobson
(1888–1963)
This bust belonged to T.E.Lawrence, who presented it to
the Tate explaining, 'Dobson the sculptor did a head in
polished brass of Osbert Sitwell. Appropriate, authentic
and magnificent, in my eyes. I think it's his finest piece of
portraiture, and in addition it's as loud as the massed bands
of the Guards'.

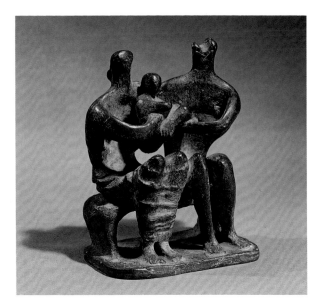

Maquette for Family Group 1944–45 by Henry Moore
(1898–1986)
This is one of three maquettes owned by the Tate out of
fourteen made by Moore in different materials in
preparation for a commission from Impington Village
College in Cambridgeshire. The commission was never
realised, but we are left with eight studies in stone, one in
terracotta and five in bronze.

Eye, Nose and Cheek 1939 (*opposite, above*) by
F.E.McWilliam (b.1909)
This semi-abstract work was made just after McWilliam
had begun to associate himself with the British Surrealists,
but he later emphasized that he was '*for* Surrealism but not
with it'. 'Eye, Nose and Cheek' has surrealist overtones
because of its associative qualities, but can also be placed
within the field of purer, formalist abstraction. McWilliam
sets the scene, 'Before the war there was a tendency to take
sides. The young sculptor was either Surrealist or abstract,
but now that we've explored both ideas, it's possible to take
a wider view without being one way or another'.

Black Crab 1952 (*opposite, below*) by Bernard Meadows
(b.1915)
Meadows (who had been an assistant to Moore in the
thirties) was one of seven British sculptors shown in the
British pavilion in Venice in 1952. Their work and its
description by Herbert Read, defined a new period in
British sculpture. Read associated a post-war form and
feeling brought together in these works: 'images of flight,
of ragged claws "scuttling across the floors of silent seas", of
excoriated flesh, frustrated sex, the geometry of fear'. The
last phrase has come down to us as a shorthand description
for this sculpture.

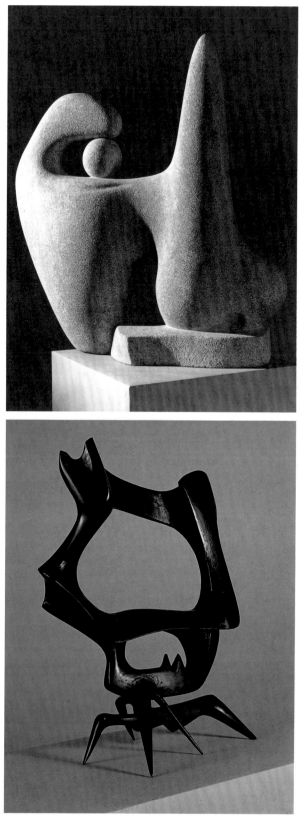

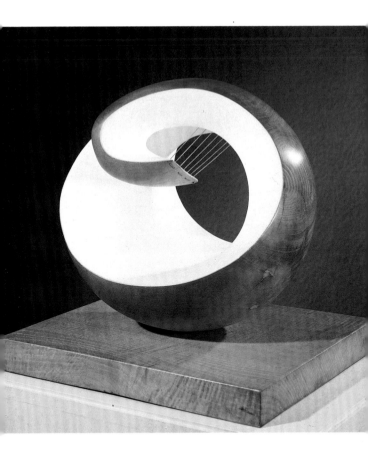

Pelagos 1946 by Barbara Hepworth (1903–75)
Pelagos belongs to a series of oval sculptures that Hepworth
began in 1943, once she moved into sufficiently large
accommodation to allow her to sculpt. It was inspired by
the grand sweep of St.Ives Bay where Hepworth had gone
in 1939 with her young family to escape wartime London.
Although it was sold soon after completion, Pelagos was
important enough to the artist for her to buy it back in 1958.

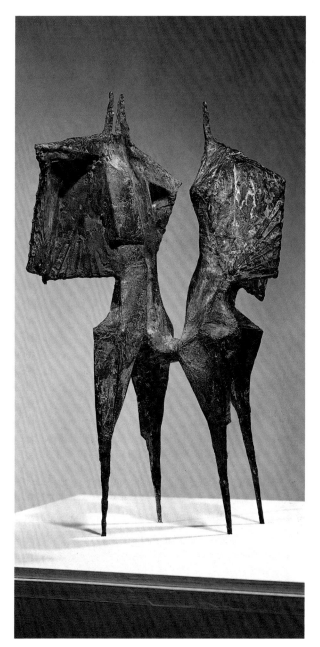

Winged Figures 1955 by Lynn Chadwick (b.1914)
Chadwick was another of the British metal-sculptors
represented at the 1952 Venice Biennale. These 'Winged
Figures' are a variation on a theme of dancing figures, and
this group is a small model for a later and larger composition
now in Brussels. Chadwick had moved from making large
mobiles in metal and glass, to welding metal, and his work
thereby moved from the linear to the planar.

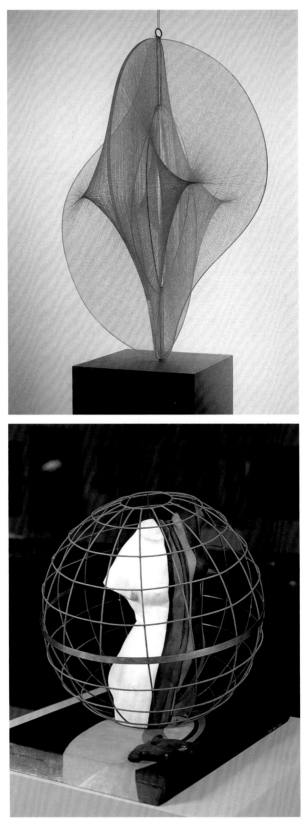

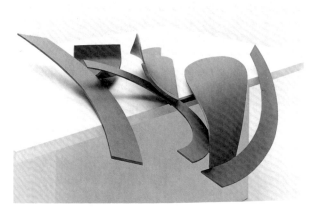

Piece LXXXII 1969 by Anthony Caro (b.1924)
Caro studied engineering before serving in the Navy, and then began to study sculpture. He was assistant to Henry Moore 1951–3, and then spent some time in America where he was influenced by the sculptor David Smith. Caro has been important as a teacher to many recent British sculptors. From 1960 he began to make metal sculpture using pre-fabricated elements. He became famous using brightly coloured welded metal placed on the ground, but then began to present unpainted metal on tables. The 'tables' were not however simply stands in the traditional sense: 'My Table Pieces are not models inhabiting a pretence world, but relate to a person like a cup or a jug. Since the edge is basic to the table all the Table Pieces make use of this edge which itself becomes an integral element of the Piece'.

Linear Construction No. 2 1970–71 (*opposite, above*) by Naum Gabo (1890–1977)
Gabo was born in Russia, spent the years of the Second World War in Britain, and died in America. He had a life-long fascination for construction, and for new materials such as perspex and nylon thread, which, with their flexibility, allowed him to realise his ideas about light, rhythm, depth and direction. This piece was presented to the Tate Gallery in memory of Herbert Read, and was deliberately kept all white to 'keep the spirit of serenity'.

The Voyage of Captain Cook 1936/67 (*opposite, below*) by Roland Penrose (1900–1984)
This Surrealist object was first exhibited at the 1936 *International Surrealist Exhibition* in London which Penrose, as one of the leading English Surrealists, helped to organize. In the true spirit of Surrealism, Penrose put together a number of objects from very different sources: the plaster torso from a Paris shop, the globe cage made for him by a bicycle repairer in London, the saw handle from his workshop. The first version was destroyed during the war; this is the second version made by the artist and his son over 30 years later.

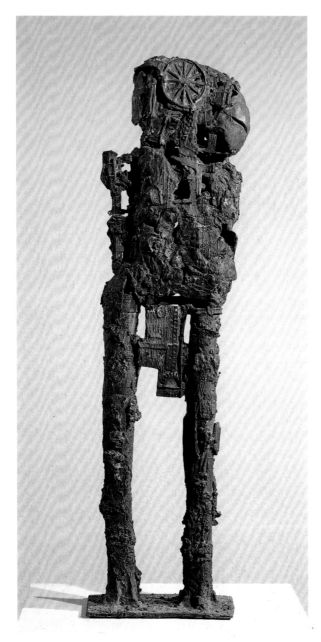

Cyclops 1957 by Eduardo Paolozzi (b.1924)
'Cyclops' is one of a number of works of the fifties which
heralded the coming of Pop Art, and which were first
exhibited in the 1956 *This is Tomorrow* exhibition at the
Whitechapel Art Gallery, London. 'Cyclops' is one of
Paolozzi's rough-cast figures of the fifties which
foreshadowed his smoother, more colourful robot-men of
the sixties. It was made in wax and then cast in bronze by
Fiorini of London.

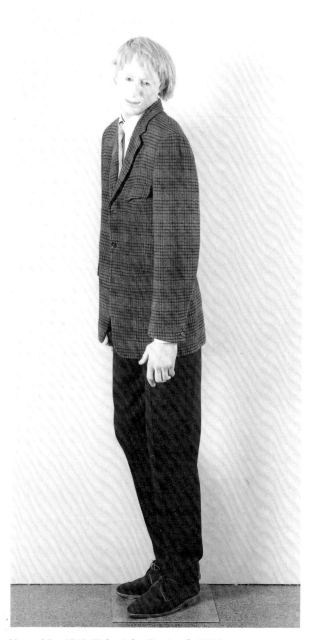

Young Man 1969–71 by John Davies (b.1946)
Davies wants the spectator to confront his sculpture as if it
were a person, not as if it were an object on a stand. For this
confrontation to work, he requires a realistic aura for his
sculptures, which should not indicate any such
individualizing or distancing factors as a style, a time or an
artist. All such qualities should fade away. 'Young Man'
shows the influence of the theatre on visual art in the sixties.

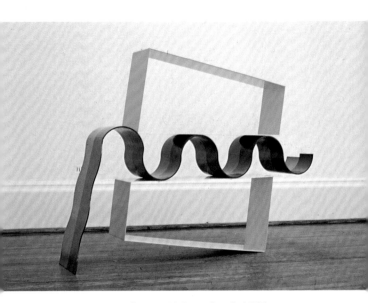

Swing Low 1964 by David Annesley (b.1937)

'Swing Low' is made of steel, and illustrates the qualities in steel which pleased Annesley; its fluidity combined with its rigidity. Annesley was one of the generation of sculptors who trained at St. Martin's School of Art, and were inspired by Anthony Caro's breakthrough into abstract sculpture using welded steel. A point in common to most of their sculpture is its very bright colour, which, for us now, seems very characteristic of the excitement of the sixties. The Tate Gallery has a good collection of these sculptures thanks·to the donation of collector Alistair McAlpine.

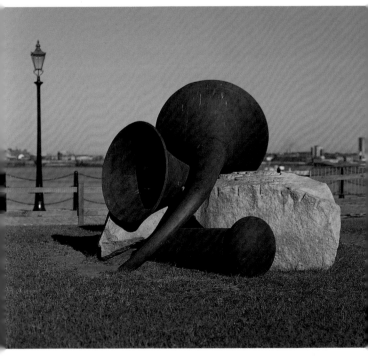

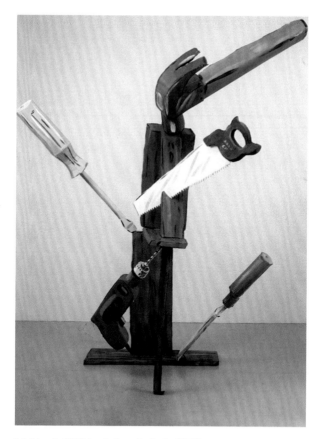

Making It 1983 by Julian Opie (b.1958)
By making a sculpture 'in action' in the process of making itself – with the most 'toolish' kind of tools – Opie is presenting a behind-the-scenes story of a sculpture. He explained this as being a comment about the sculpture of the seventies, but more importantly, it's about 'one thing doing something to another like a match lighting a cigar. This gives a reason to the match and cigar, or the tools and the sculpture. They support each other – visually and physically'. The tools were made in the most direct way – by drawing their outlines onto sheet steel with chalk, cutting them with a welding torch, bending them into shape and welding them together.

Raleigh 1986 (*opposite, below*) by Tony Cragg (b.1949)
Cragg returned to his hometown of Liverpool to make a sculpture for this site beside the Tate. He used different materials from those he normally worked with to respond to the dock site, and Liverpool's tradition of heavy industry. He selected two granite and a number of cast iron bollards from an artefact store, and the casts for the sculpture were made from Cragg's drawings in the Bootle iron foundry, Bruce & Hyslop. The horns symbolize a fanfare of greeting or farewell, and also suggest messages carried across the water.

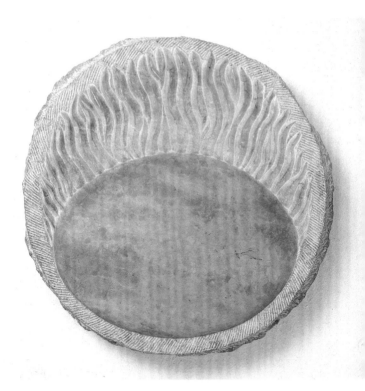

Tondo 1981 by Stephen Cox (1946)

'Tondo' is made from red marble from Verona, where it was carved, under Cox's supervision, by local craftsmen. Stephen Cox is very interested in traditional Italian carving, and he has tried to use all the marbles mentioned by the 16th century art historian Vasari. Adrian Stokes, a British art historian of this century, who also loved the effects obtained in stone by Italian Renaissance craftsmen, thought that Verona marble produced a particularly lovely 'stoneblossom'. For a title Cox took a line from the end of Stokes' book, which reflected Stokes' passion for the warm south: 'Or do we all need light in place of lightning – must we always turn south?'. Another sculpture by Cox, 'Palanzana', can be seen in the Festival Gardens, and its maquette is in the Walker Gallery.

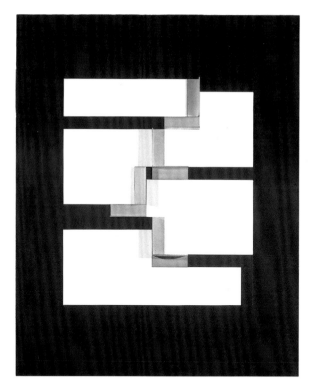

Relief Construction 1960–62 by Anthony Hill (b.1930)
Hill made his first relief in 1954, and soon abandoned
painting, devoting himself entirely to reliefs. This
construction is one of a series begun in 1960 following
a mathematical formula. Hill wrote, 'the theme involves a
module, a partition and a progression'.

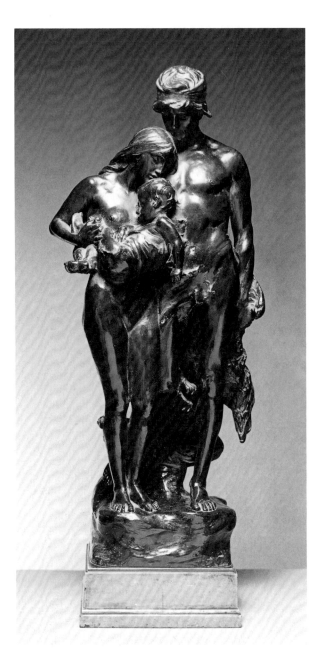

Rescued 1899 by Charles John Allen (1863–1956)
Allen was Hamo Thornycroft's chief modelling assistant,
but becomes more significant to us in 1895 when he began
to teach sculpture in Liverpool at the new School of
Architecture and Applied Art. He was closely associated
with Birkenhead's Della Robbia pottery, and the two
sculptures with which he won a gold medal at the 1900 Paris
International Exhibition, 'Rescued' and 'Love and the
Mermaid', are aptly conserved in the museums of
Birkenhead and Liverpool. The Williamson's 'Rescued' is a
smaller version of the bronze bought by Queen Alexandra.

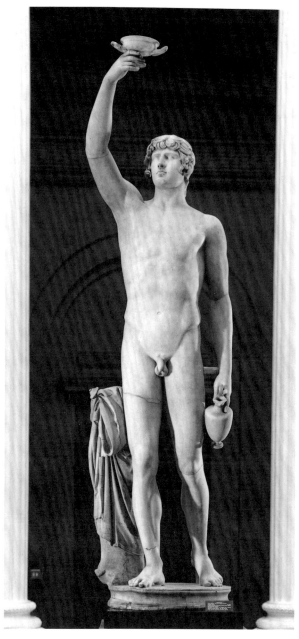

Antinous 2nd century A.D.
This is a Roman statue in the style of early Greek classical
sculpture of Antinous, dearly beloved by Emperor Hadrian.
Antinous drowned in the Nile in A.D.130 and became
something of a celebrity after his death. It is likely that
Antinous is represented here offering ambrosia to Hadrian.
The Hope brothers bought it from the restorer Pierantoni in
Rome in 1796, and his restorations to the statue are easy to
see. 'Antinous' was the second most expensive statue sold at
the Hope auction of 1917.

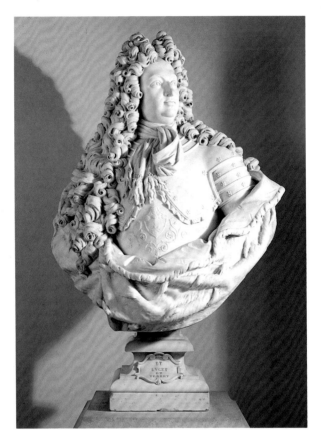

Ferdinando de'Medici c.1700 by Giovacchino Fortini
(1671–1736)
The subject was the son of Cosimo III, Grand Duke of
Tuscany, who outlived Ferdinando. The son achieved
celebrity, however, as a distinguished patron of the arts,
thus following in the footsteps of his Renaissance ancestors.
The inscription on the base, and the lightning striking
though clouds on his breastplate, are his motto.

Leda and the Swan 1898 (*opposite, below*) by Desiré Maurice
Ferrary (1852–1904)
'Leda' was exhibited alongside 'Salammbo' (see page 52) at
the 1900 Universal Exhibition in Paris, where Lever
probably bought them both. Again, the different materials
used for the different characters in the story emphasize prey
and predator, female and male, for Zeus took the form of a
swan so as to ensnare Leda.

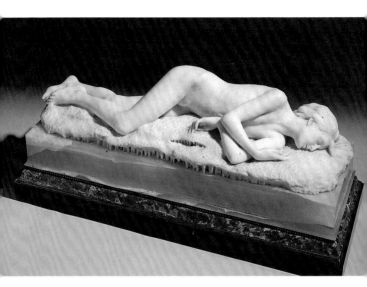

Snowdrift 1901 by Edward Onslow Ford (1852–1901)
Onslow Ford was at work on 'Snowdrift' in the last few
months before his death; it was completed by his son and
exhibited posthumously at the 1902 Royal Academy
exhibition. It looks at French prototypes of the naked
female figure prostrate on the ground, but also at his own
works such as the drowned Shelley on the 'Shelley
Memorial' in Oxford. Onslow Ford is represented by other
works on Merseyside: 'Peace' in the Walker, and 'Folly' and
'Fate' at Port Sunlight. His dainty touch represents a high
point of the *New Sculpture* of the late 19th century, which
drew on French inspiration to move away from dry
classicism to focus on subjects of more emotive and human
interest.

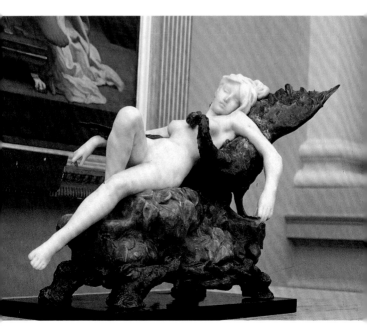

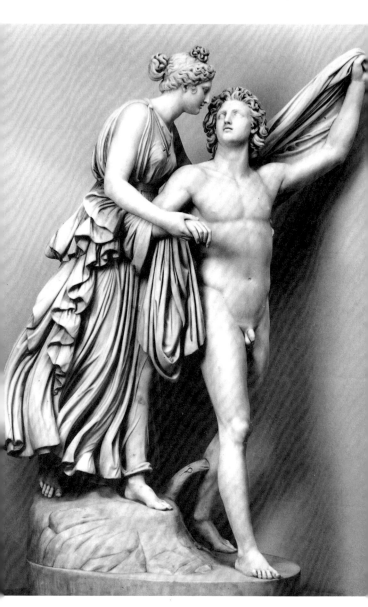

Cephalus and Aurora 1791 by John Flaxman (1755–1826)
This work was commissioned by Thomas Hope from
Flaxman in 1790. The largest surviving part of Hope's
collection came to Port Sunlight when Lever bid for it at the
auction of 1917. In this work Aurora, Goddess of Dawn,
descends from Mount Ida to visit Cephalus, whom she has
enticed away from his wife. Their son was to be the
Morning Star. Flaxman worked for Wedgwood from 1775,
designing cameos and making wax models of classical
friezes. Wedgwood sent him to Italy in 1787, where he
stayed for seven years. With his careful line illustrations for
the *Illiad* and the *Odyssey* Flaxman became famous and
influential throughout Europe.

Castles in the Air 1901 by W. E. Reynolds–Stephens
(1862–1943)

Reynolds-Stephens was very influenced by other sculptors
represented in Liverpool, Frampton and Gilbert, and by
current interest in *Arts and Crafts* ideas and experiments with
techniques such as polychromatic sculpture and electro-
deposit process. Such sculptors hoped to expand sculpture's
role and its materials. He designed decorative schemes for
the interior and exterior of buildings, relief panels and
dishes, as well as ideal and commemorative sculpture.

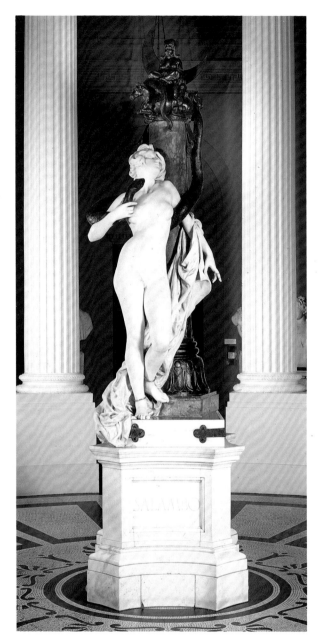

Salammbo 1899 by Desiré Maurice Ferrary (1852–1904)
The subject is drawn from Flaubert's novel of 1862, and
Salammbo enjoyed renewed vogue at the end of the century.
Here we see Salammbo, the sister of Hannibal, setting off
for the Barbarians' camp to retrieve the Carthaginian veil,
their talisman of good-luck. Before going, she entwines
herself with a python, symbol of Carthage, so as to draw
inspiration from it; she is about to take its jaws into her own
mouth. The use of two materials emphasizes the erotic
vulnerability of the woman and was a much-used device in
French sculpture of this period.

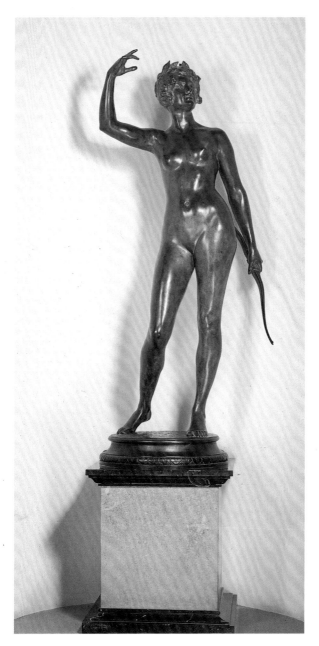

Wood Nymph c.1900 by F.W. Pomeroy (1856–1924)
Pomeroy is an important member of the group of *New Sculptors* so well represented on Merseyside. 'Wood Nymph' was originally exhibited under the title of 'Feronia', who was a woodland goddess widely worshipped in Italy in pre-Christian times. In this work we see her glance following an arrow released from her bow.

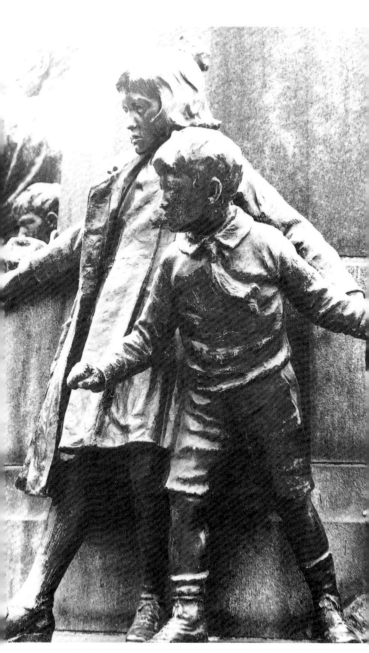

Port Sunlight War Memorial 1921 by William Goscombe John
(1860–1952)
This memorial combines images of soldiers in action on the
Front with the patient endurance of those on the Home
Front; mothers and children. The four sections of the
parapet are faced with bronze groups representing the three
sections of the Armed Forces, along with the Red Cross.
Goscombe John had executed a bust of Lady Lever in 1912,
and her tomb in Port Sunlight, three years later. This local
connection was confirmed in 1919 with this commission.

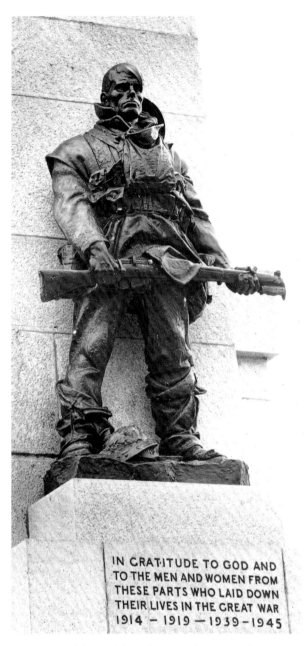

IN GRATITUDE TO GOD AND
TO THE MEN AND WOMEN FROM
THESE PARTS WHO LAID DOWN
THEIR LIVES IN THE GREAT WAR
1914 — 1919 — 1939 — 1945

War Memorial for Hoylake and West Kirby 1919–20 by
Charles Sargeant Jagger (1855–1934)
George Frampton recommended Jagger (who had just
recovered from his war wounds) for this commission which
was to be the first of several. It enabled Jagger to put into
practice some of his developing ideas for war memorials,
revealing his emphasis on the architectural side of
monumental sculpture, and on commemorating ordinary
soldiers. To use a British 'Tommy' on a monument would
never have been done in the 19th century, and indicates the
new and different mood behind the commemoration of the
First World War.

Grange Hill, Grange Road, West Kirby 55

Red Between 1971–3 by Philip King (b.1934)
'Red Between' was bought by Liverpool University in 1977
to install outside the Sidney Jones Library. King came to
Liverpool to supervise its erection and siting. 'Red Between'
reveals King's development from the earlier pieces on
display in the Tate; it is metal rather than plastic, open rather
than closed. It shows King grouping elements, rather than
using them in sequence. During the first stage of its building
(which lasted two years), the groups of elements were low
on the ground. In the interval 'Blue Between' and 'Yellow
Between' were constructed at a higher level, and when King
came back to the Liverpool piece, he lifted its elements too.

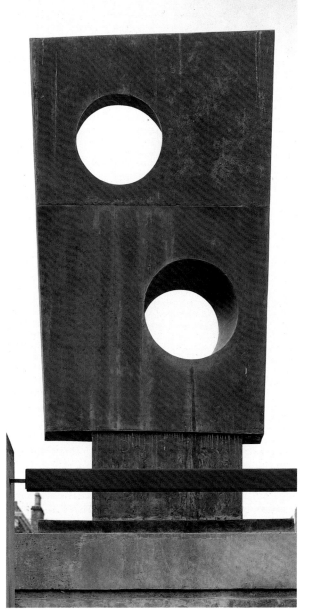

Squares with Two Circles 1963 by Barbara Hepworth
(1903–1975)

In the late fifties the differences between materials became
less important to Hepworth, who began to move more
smoothly between them. At the same time, she began to
shift in scale, rather than adhering strictly to scale for each
work. In the early sixties, squares and rectangles suddenly
began to appear in her work, which had previously been
curvaceous and rounded. This must have been a response to
finding a working process and style to meet the demands of
public sculpture. Now the setting of the sculpture became as
important as the surface had been before.

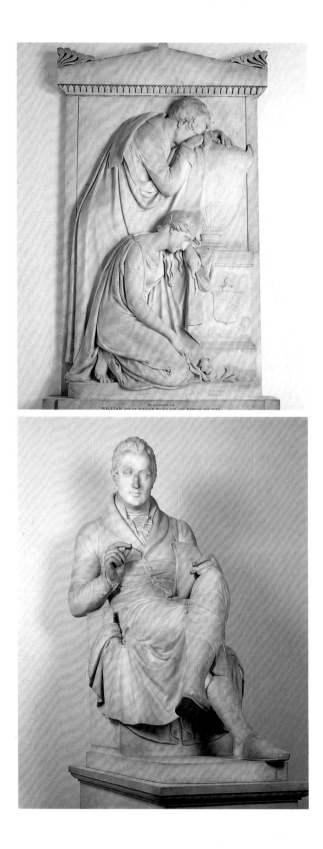

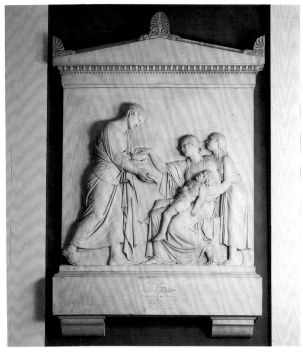

Monument to William Hammerton by John Gibson (1790–1866)
Hammerton's 'affectionate niece' raised this monument to
'The friend of the afflicted The Munificent Patron of the
Charitable Institutions of this town' who had died in 1832.
Gibson executed it in Rome.

Monument to William Nicholson 1834 *(opposite, above)*
Sir Francis Chantrey (1781–1841)
This monument was erected in memory of the children of
William and Hannah Nicholson. Chantrey's work in tomb
sculpture is significant for its originality; he was a master of
charming memorials to children, and of sober monuments
to great men. He was born near Sheffield, and spent his
working life in London. Despite difficult beginnings and
the lack of formal instruction, Chantrey ended his career
leaving a substantial body of work, especially busts, and a
large legacy which went to establish the Chantrey Bequest
from which the Tate Gallery has ever since benefited.

Monument to William Ewart (opposite, below) by Joseph Gott
(1786–1860)
The merchant William Ewart settled in Liverpool early in
life, and became a close friend of Gladstone's father. William
Gladstone inspected the work in Gott's studio in Rome.
Like his master Flaxman, Gott spent long periods of his
career in Rome. It was on his first return to England in 1827,
that he received this and other commissions from his close
relations, the Gott family of Leeds. In 1829 Gott was
hurrying to finish a model of the monument so that it would
catch one of the few ships bound direct for Liverpool. The
marble was carved during 1832, but took longer than
expected because his assistant had malaria.

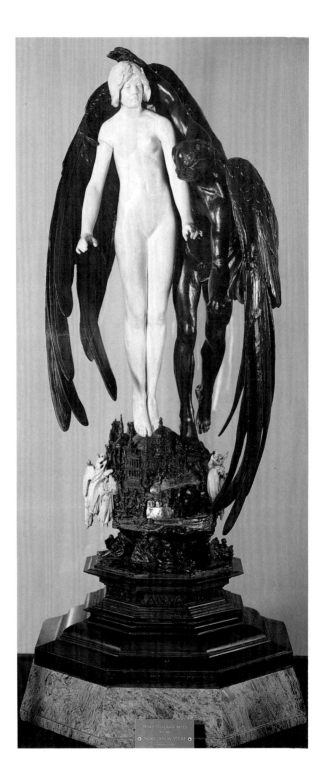

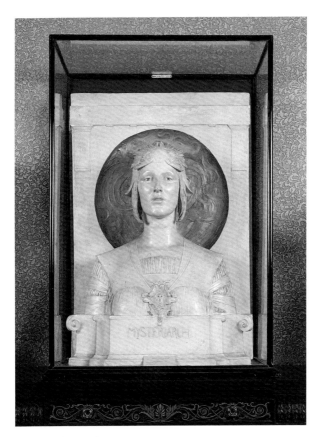

Mysteriarch 1893 by George Frampton (1860–1928)
Frampton returned from his studies in Paris to develop a
highly personal symbolist style in 'Mysteriarch', in which
four influences are visible: contemporary French and early
Italian Renaissance decorative sculpture, the sculptor Alfred
Gilbert and the Pre-Raphaelite Edward Burne-Jones. There
are other works by Frampton in Liverpool: a replica of his
famous 'Peter Pan' is in Sefton Park, a monument with the
figure of Liverpool on Pierhead, and several reliefs in the
Walker. His monument to Queen Victoria (a version of that
designed for Calcutta) is in St. Helens.

Mors Janua Vitae 1899 (*opposite*) by Harry Bates
(1850/1–1899)
In Paris Rodin was a formative influence on the young
Bates, who picked up both the physical energy and the spirit
of contemplation embodied within his sculptures. Bates'
reliefs – fine metal panels for interiors, and terracotta and
stone friezes for exteriors – illustrate the interest by the *New
Sculptors* to involve sculpture in all kinds of environments.
Their other important interest – in using varied and unusual
materials – is splendidly embodied in Bates' 'Mors Janua
Vitae' in bronze, ivory and mother-of-pearl, which uses
ivory for the girl, and bronze for Winged Death. The
materials enhance the story.

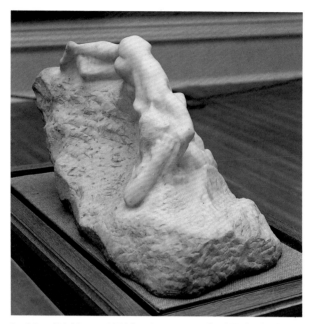

La Mort d'Athènes c.1902 by Auguste Rodin (1840–1917)
There is another marble of the same title, but without the
dying female figure representing Athens, in the Rodin
Museum in Paris. The Walker's version is much closer to
one in the Thyssen-Bornemisza collection. It was bought
from the artist by James Smith of Blundellsands for 23,000
francs, who bequeathed it, and five other Rodins, to the
Walker in 1923 and 1927. Smith and his wife chose a marble
version in preference to one in bronze. Rodin's sculptures
were never fixed either in image or medium; they were
reproduced in varying and fluid ways, generally by one of
his many assistants. *Sudley Art Gallery and Museum*

Tango 1984 by Allen Jones (b.1937)
Allen Jones is best known for his prints and paintings of the
female form frequently in silhouette or line. In the early
eighties he began to fashion a sequence of dancing forms,
some dancing alone, others in couples. He began by
working in paper and wood, but this piece is constructed
from steel plate with the help of Paragon Engineering.
'Tango', commissioned for the 1984 Liverpool Garden
Festival, was Jones' first public sculpture, and was one of
eight sculptures specially commissioned for the Festival.

Sitting Bull 1984 (*opposite, below*) by Dhruva Mistry (b.1957)
Before this sculpture was executed for the Liverpool Garden
Festival of 1984, Mistry had executed two smaller bulls, and
a model for this one which is now in the Walker Art Gallery.
This bull is derived from Nandi, the 'pet' of the Hindu god
Shiva. It is made of coloured concrete on metal armature,
and its colour is meant to emphasize that it is more than just
a bull. Mistry said that he wanted 'to make a bull which
would make a tiger run away'.

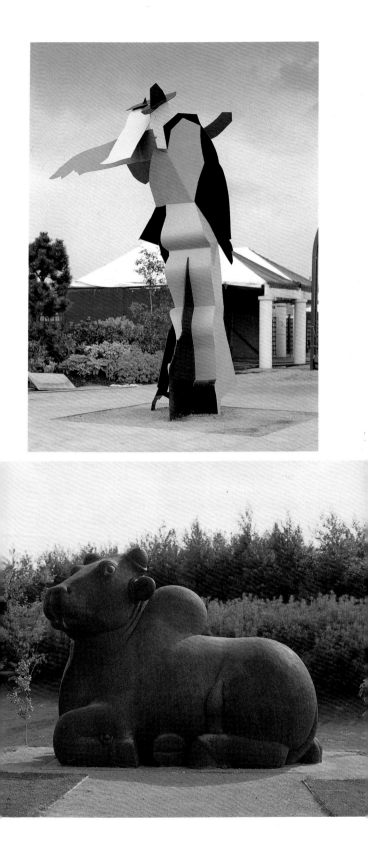

Festival Gardens, Liverpool

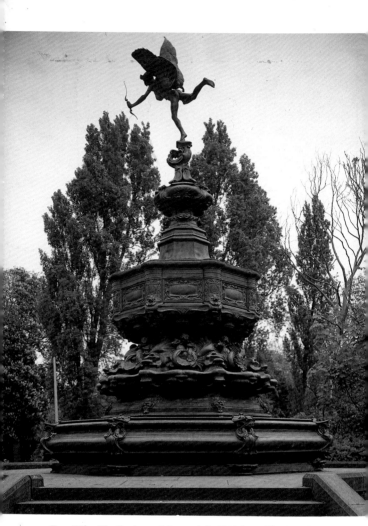

Eros (The Shaftesbury Memorial) 1893 by Alfred Gilbert
(1854–1934) (Exact replica of the monument in Piccadilly
Circus, London.)

This is an unusual way to represent a great man, Lord
Shaftesbury, and in that we now know it simply as 'Eros', it
might be said to have failed as a monument. Nevertheless,
the fact that we know it at all is probably precisely because
Gilbert rejected the conventional formula of bust or statue
on a pedestal. Instead, we have nothing to remind us of the
physical appearance of Shaftesbury, whose generous actions
for the less-fortunate are symbolized by Eros or Love.
Gilbert's virtuosity at handling scale, be it large or minute,
and material, in mass or in detail, made him the single most
influential sculptor of the time. He executed a number of
memorials for the English Royal Family, and is also noted
for his gold and silver-smithing.